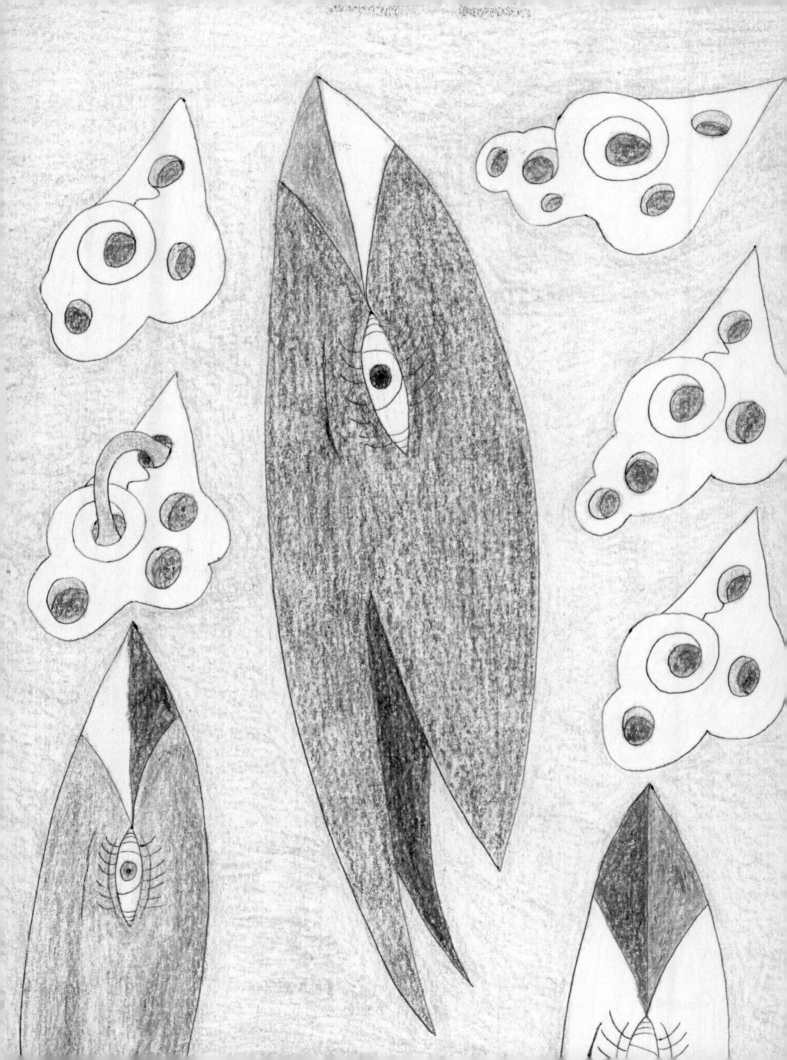

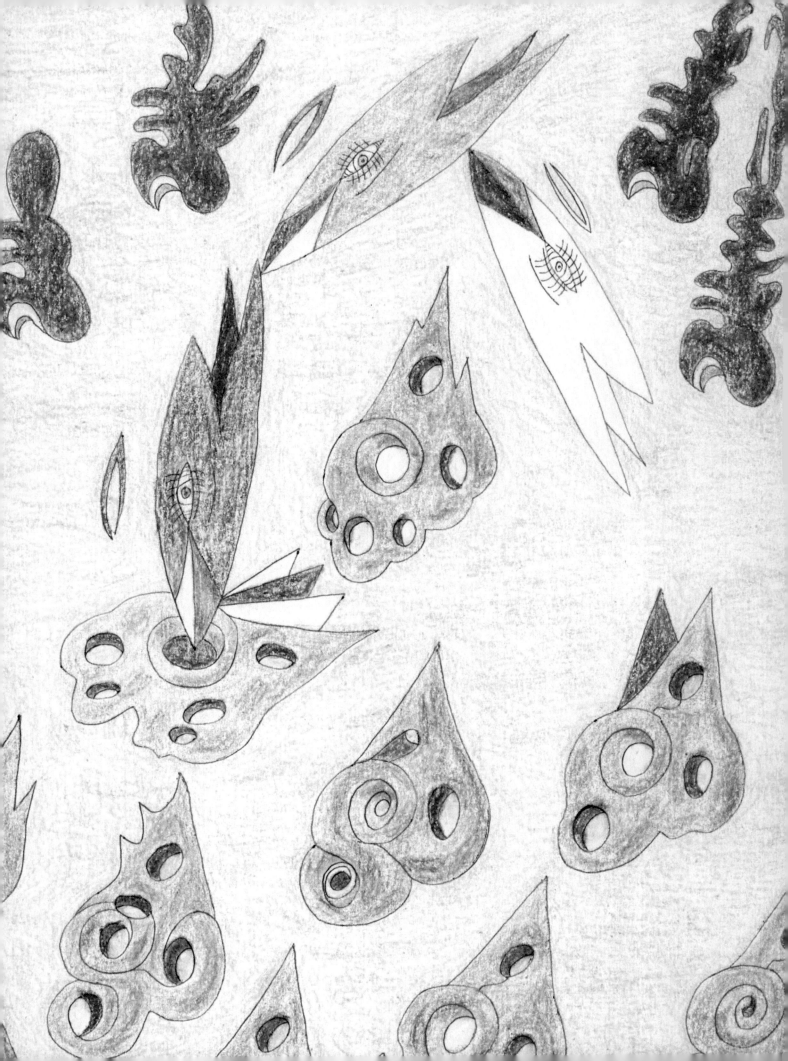

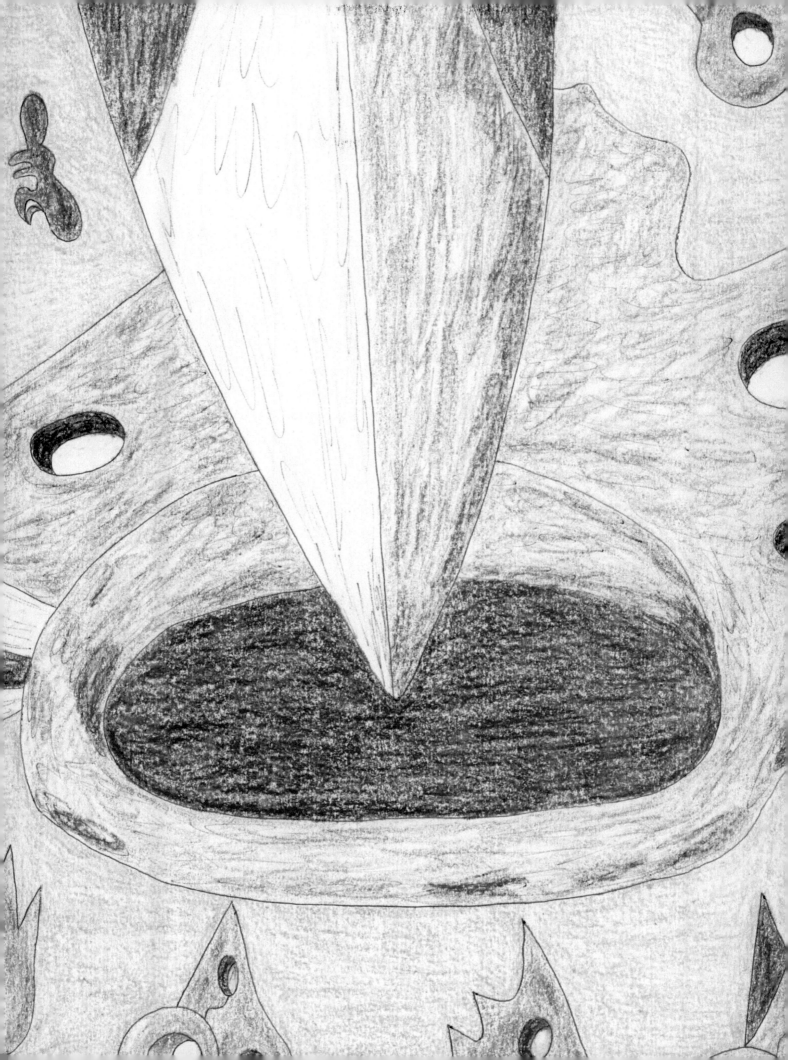

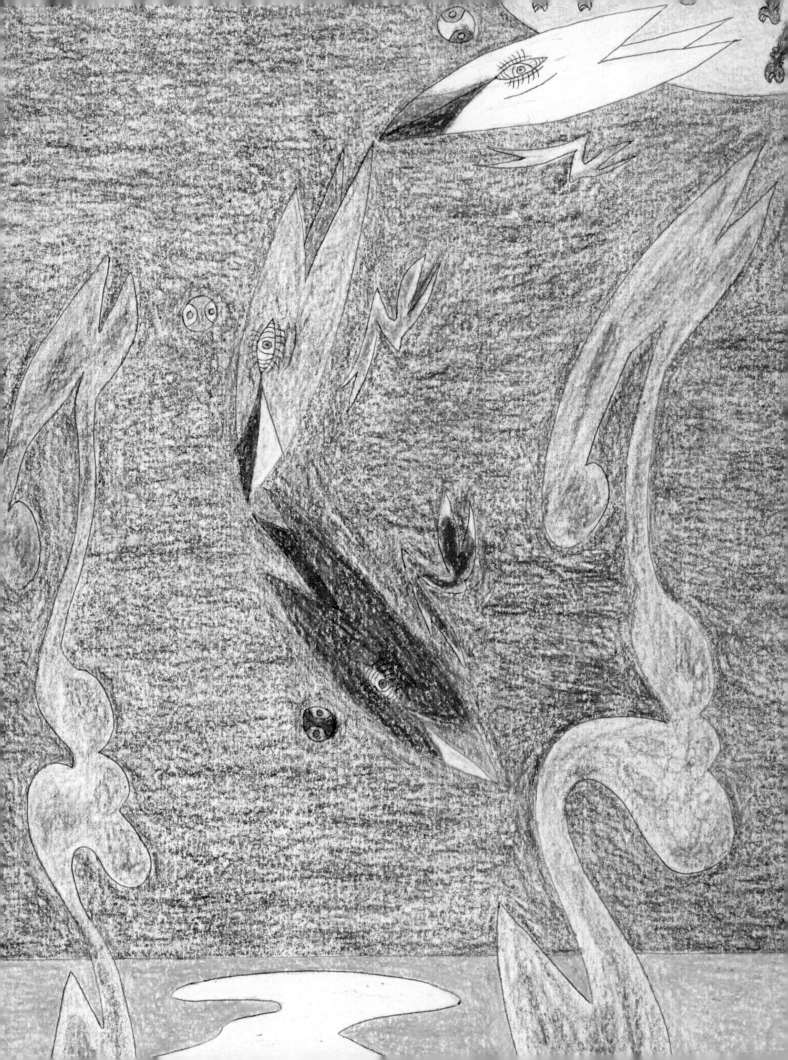

Order this book online at www.trafford.com
or email orders@trafford.com

Most Trafford titles are also available at major online book retailers.

Printed in Victoria, BC, Canada.

ISBN: 978-1-4269-3761-3 (sc)

*Our mission is to efficiently provide the world's finest, most comprehensive book publishing
service, enabling every author to experience success. To find out how to publish your book, your
way, and have it available worldwide, visit us online at www.trafford.com*

Trafford rev. 6/25/2010

www.trafford.com

North America & international
toll-free: 1 888 232 4444 (USA & Canada)
phone: 250 383 6864 ♦ fax: 812 355 4082

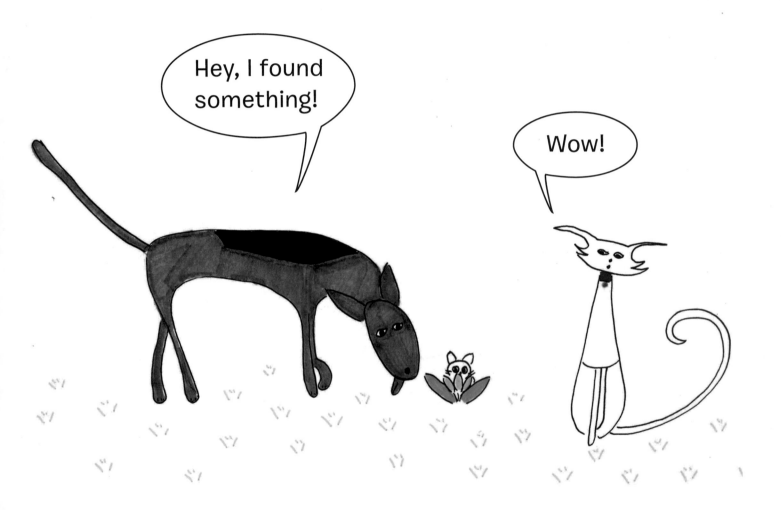

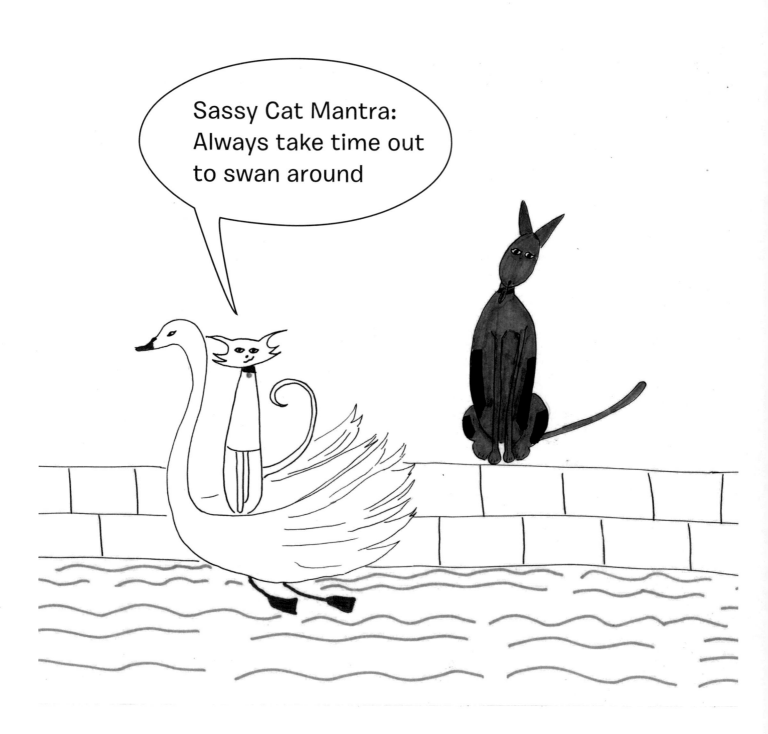

Life's truest happiness is found in the friendships we make along the way

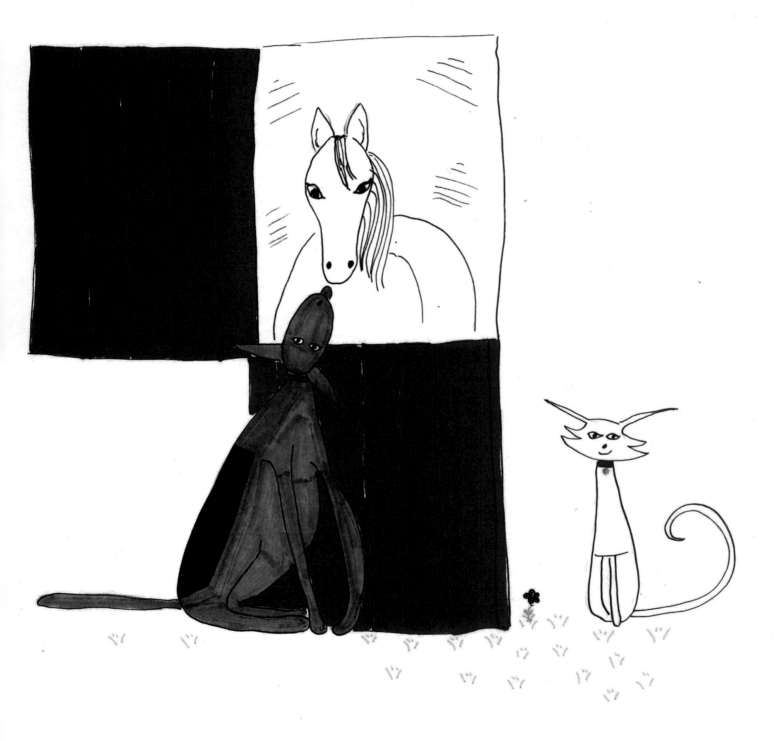

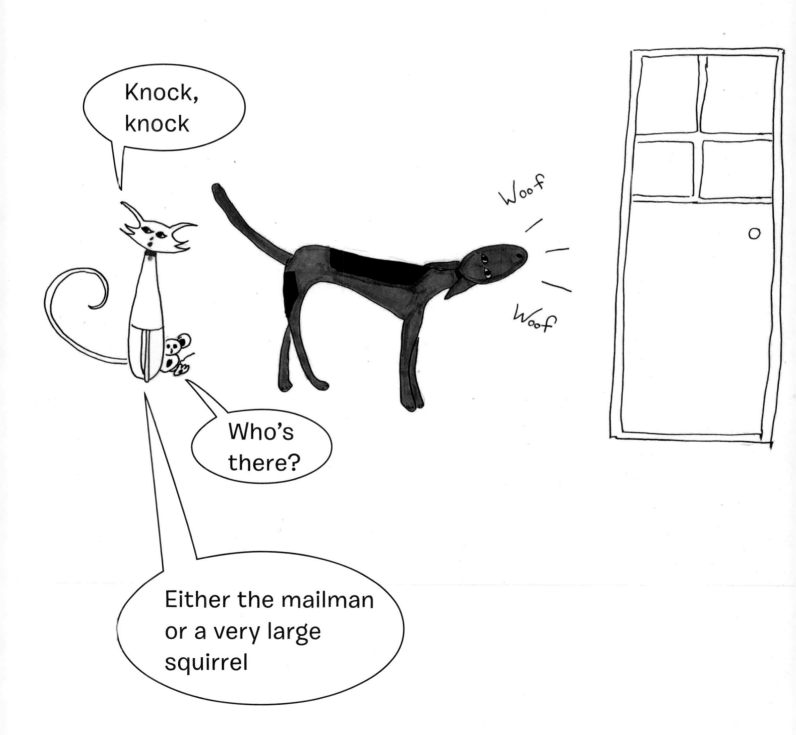

Sassy-tude is a little thing that makes a BIG difference

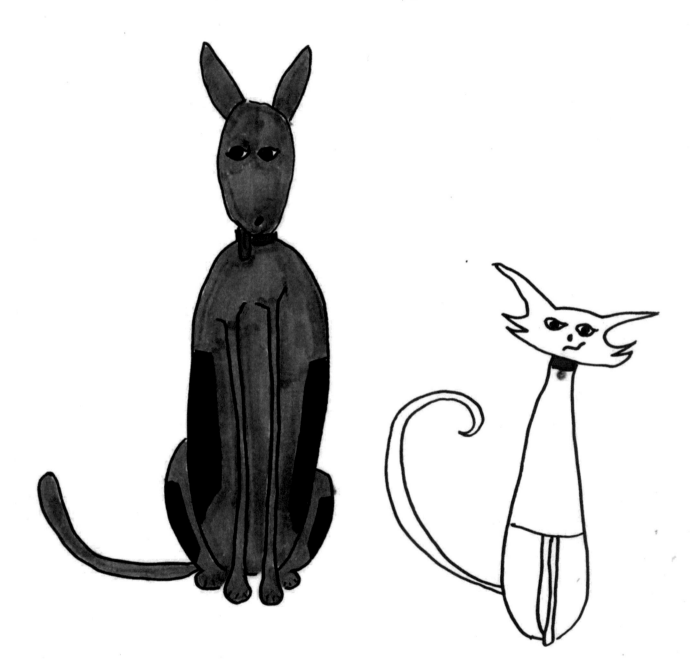

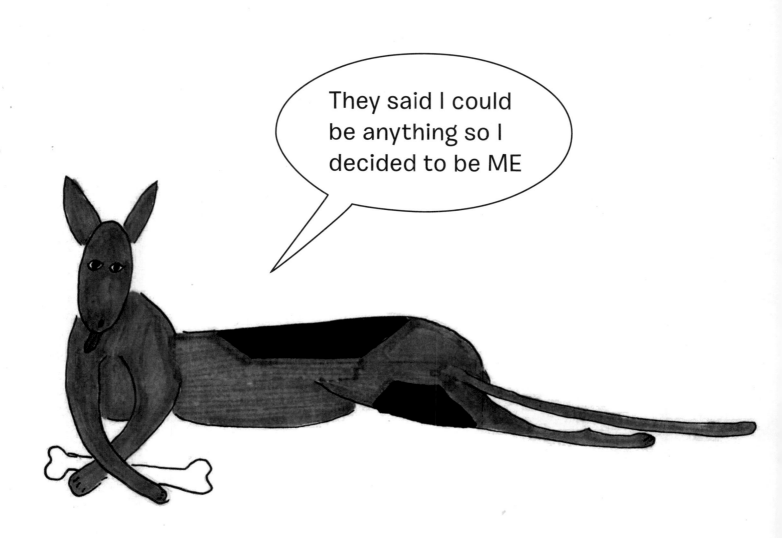

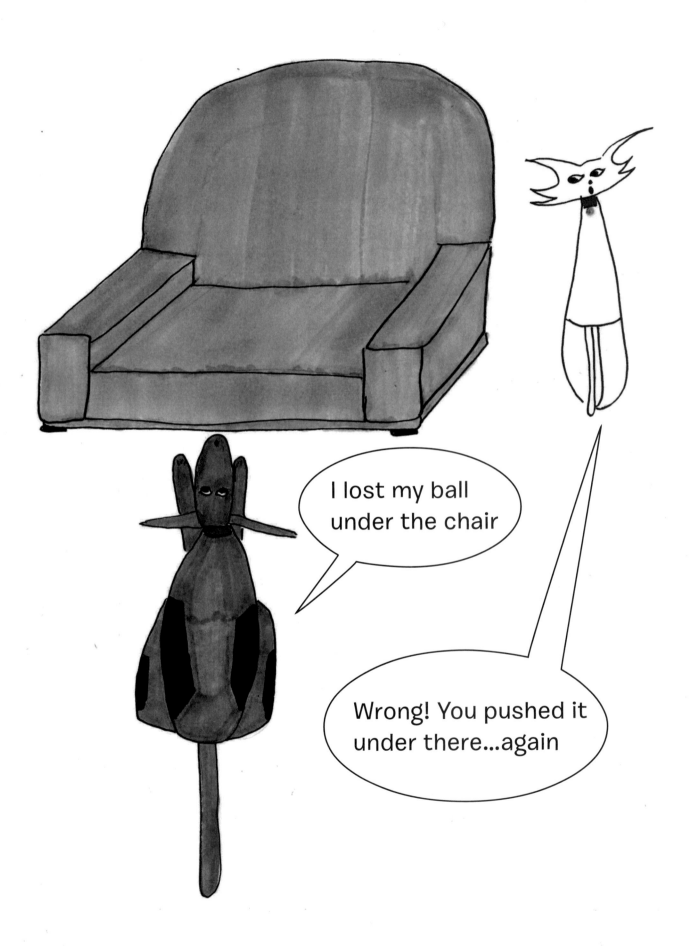

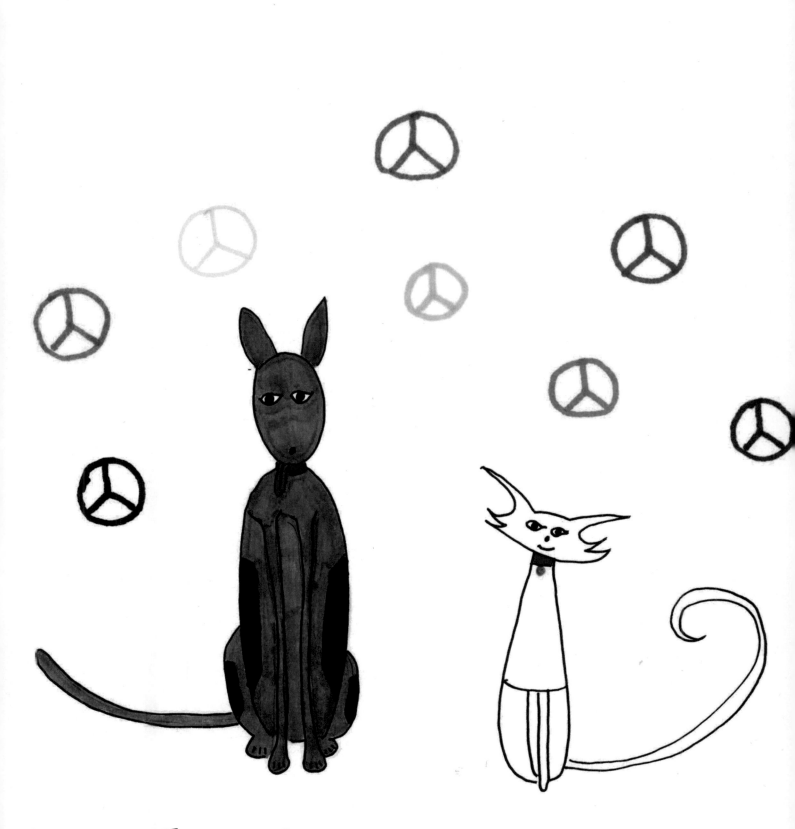

Your vibe attracts your tribe

Chase Adventure

In this House the Dog
Kat is in charge

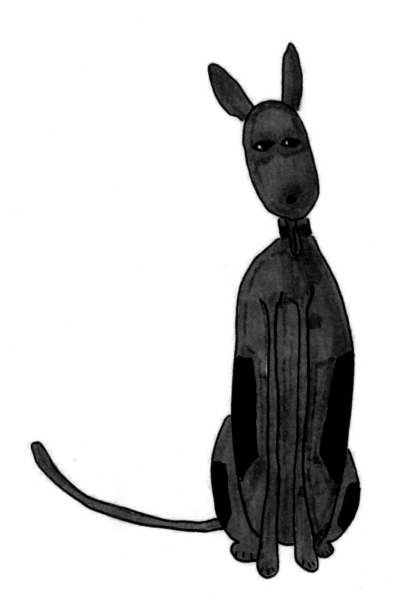

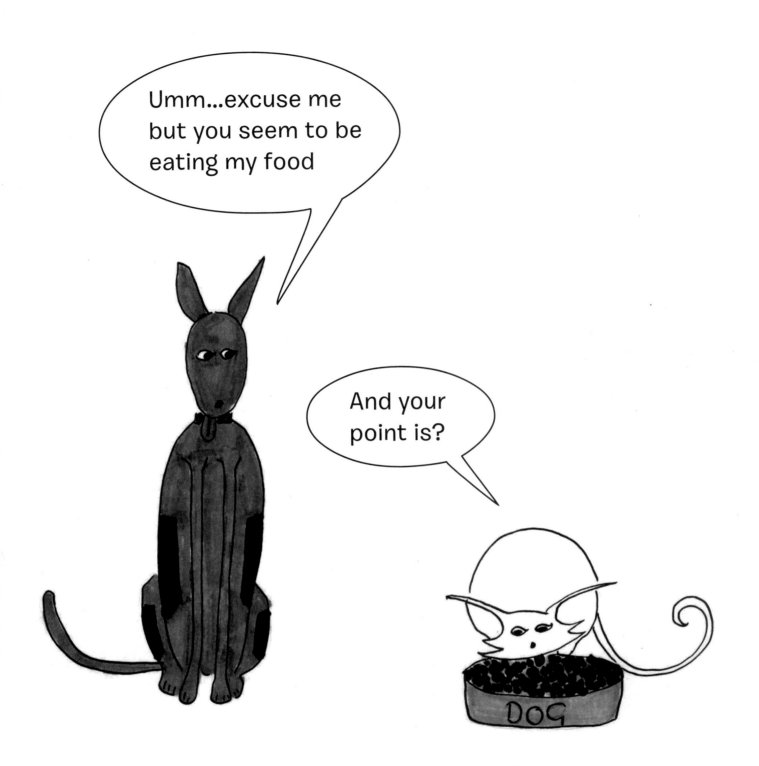

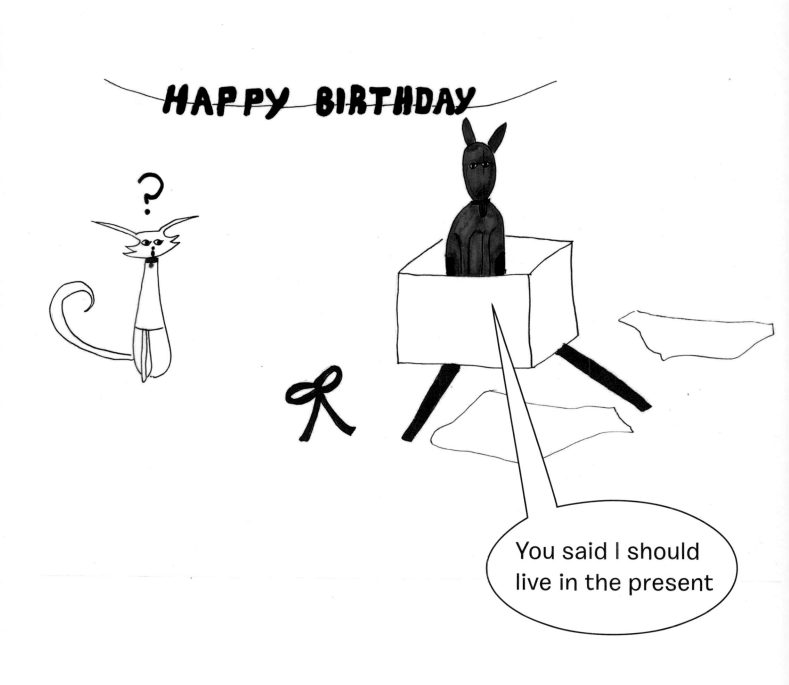

Love is like a flower

We all smile in the
same language

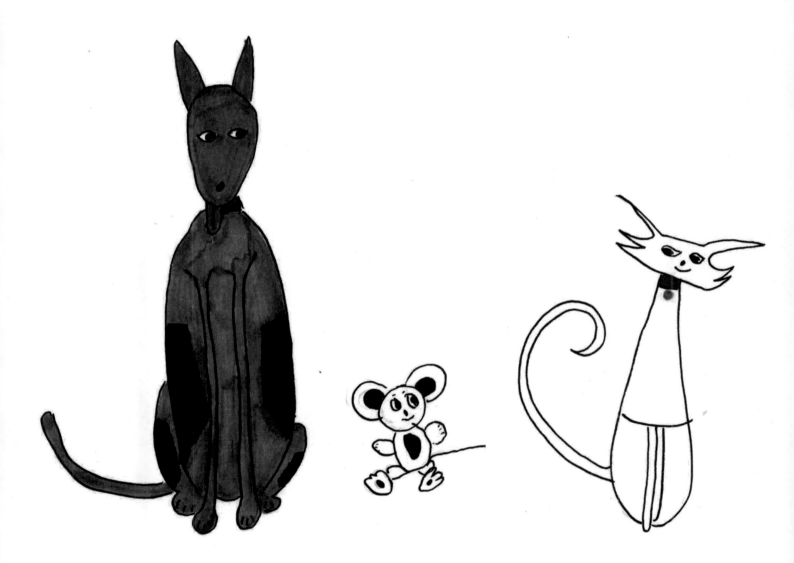

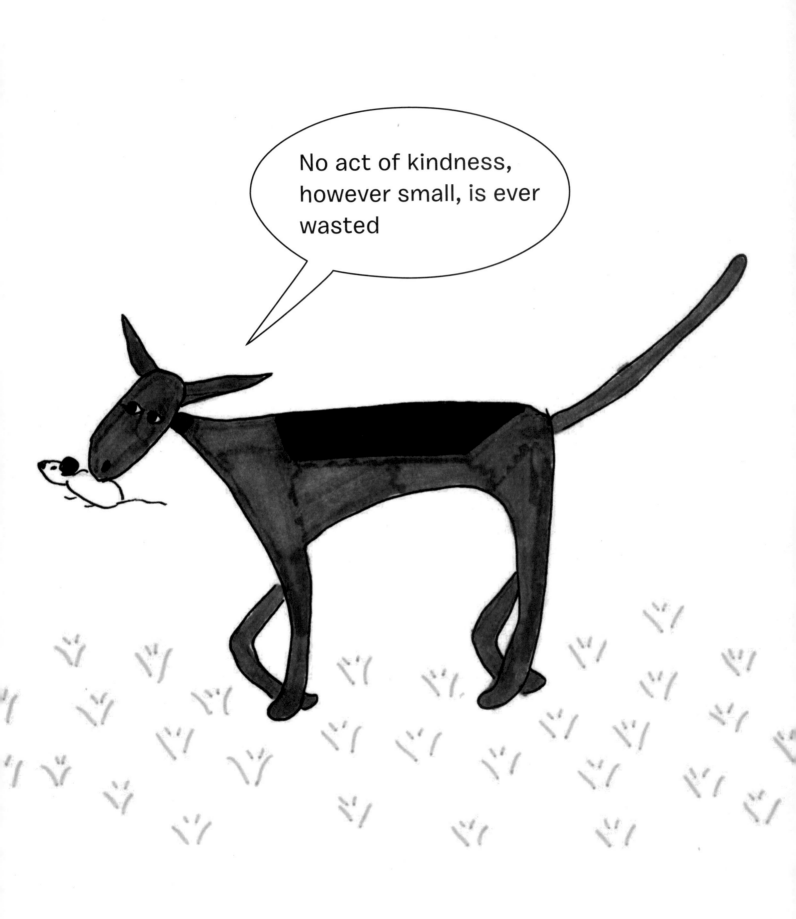

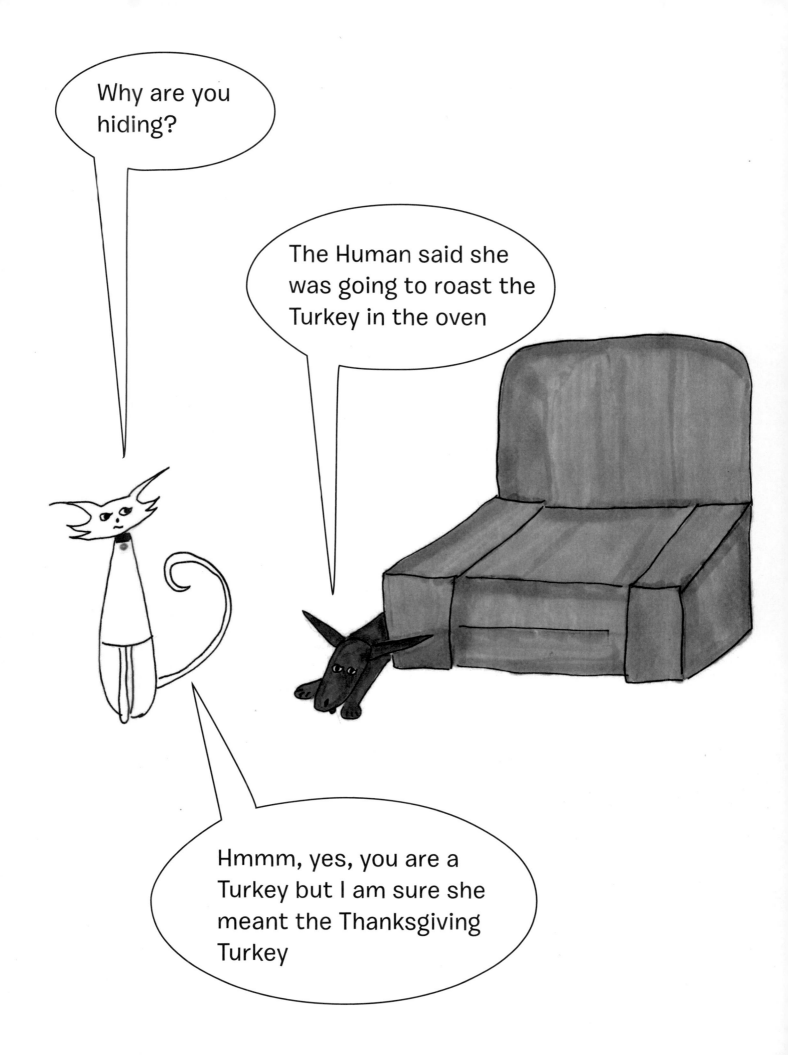

Dream Big

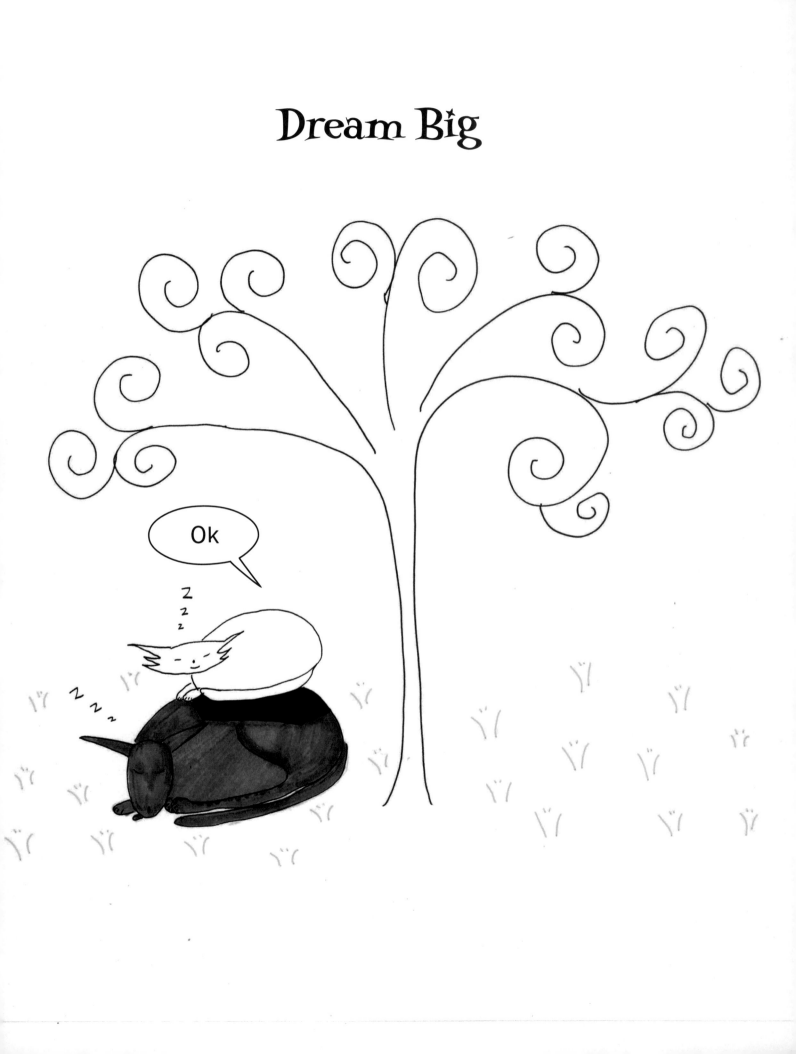

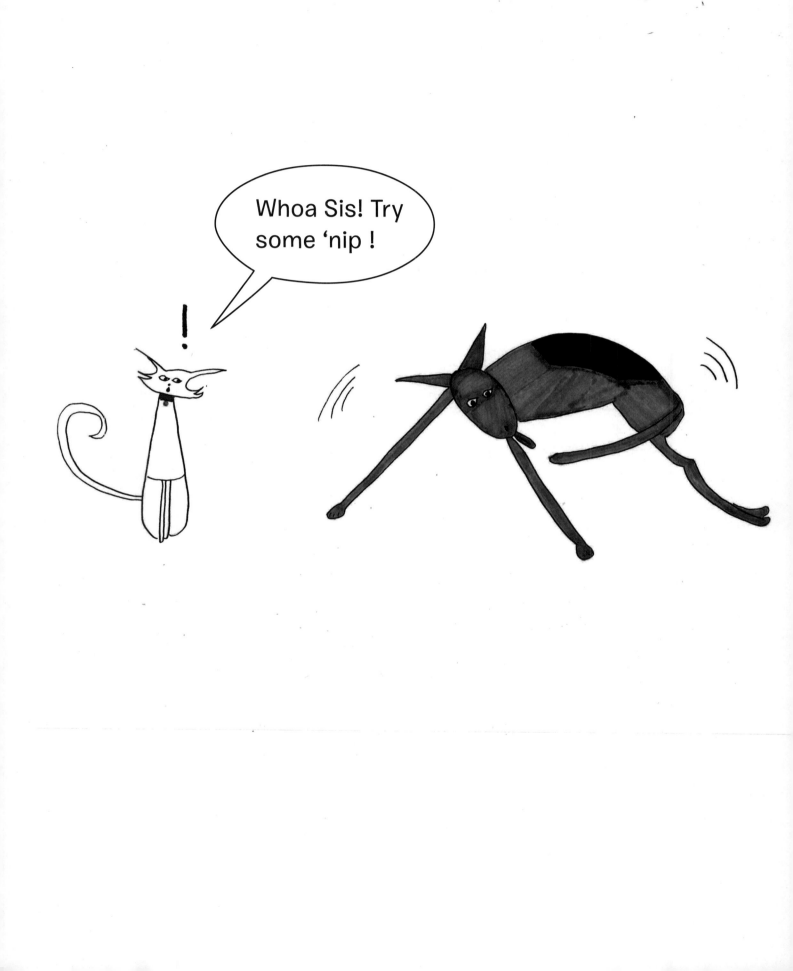

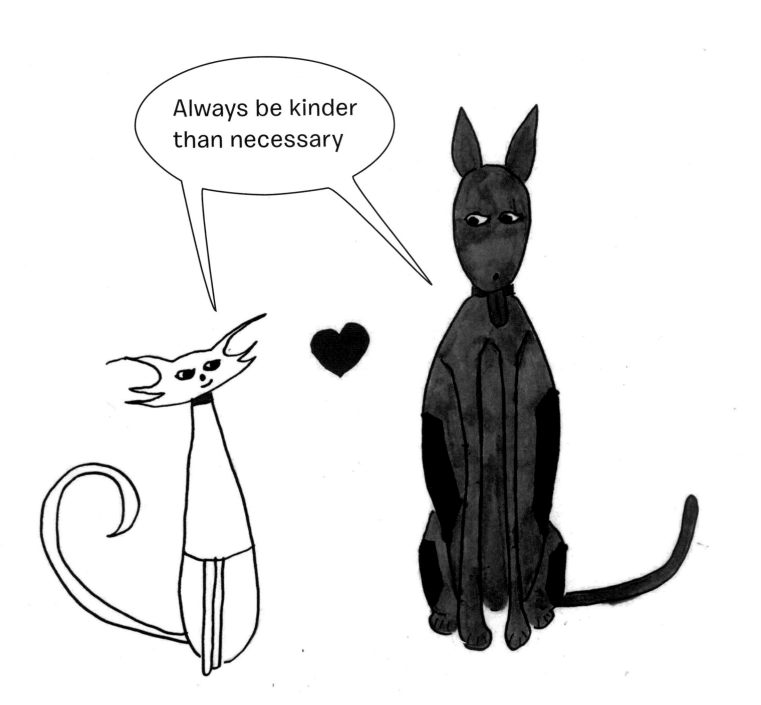

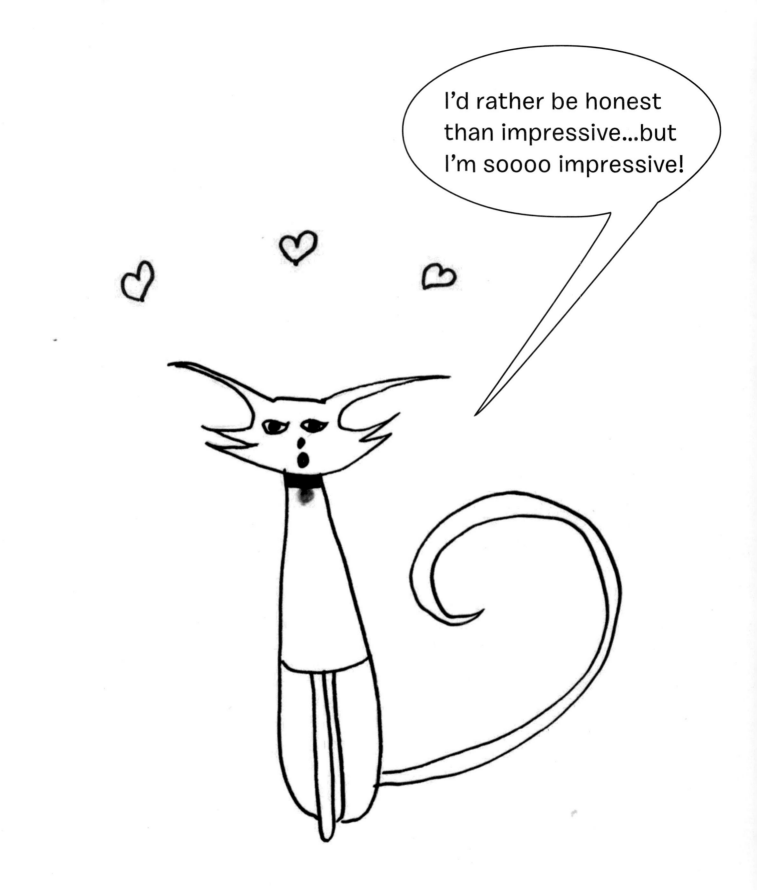

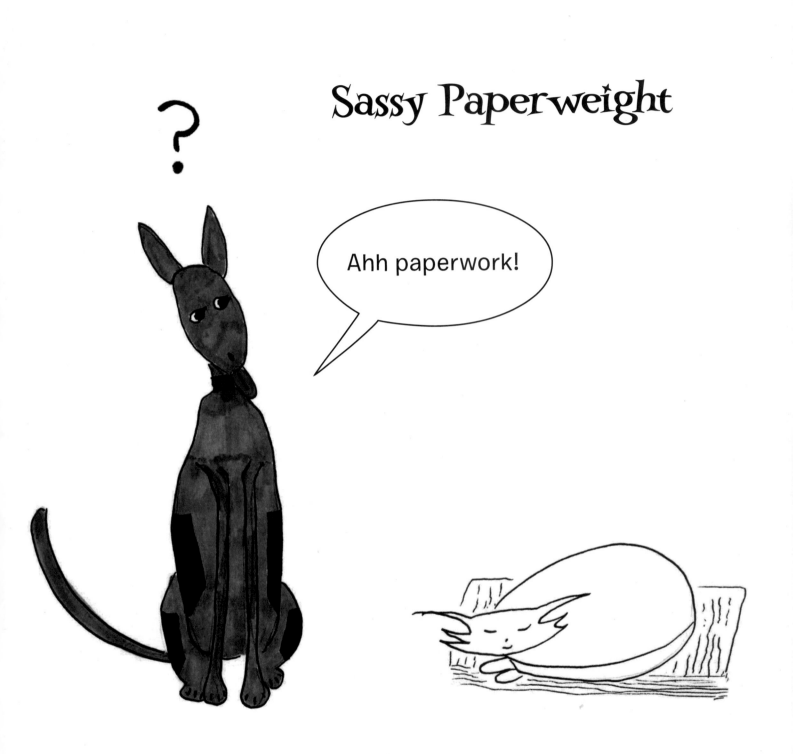

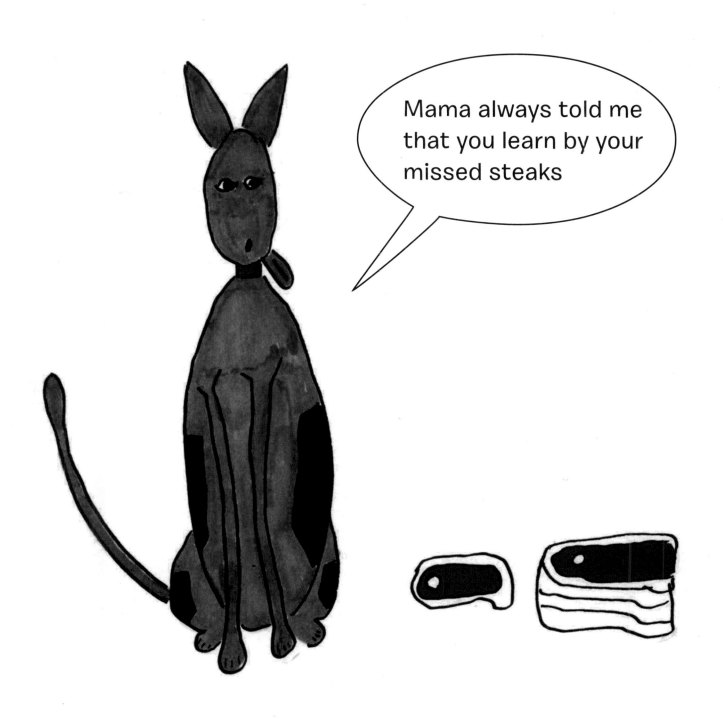

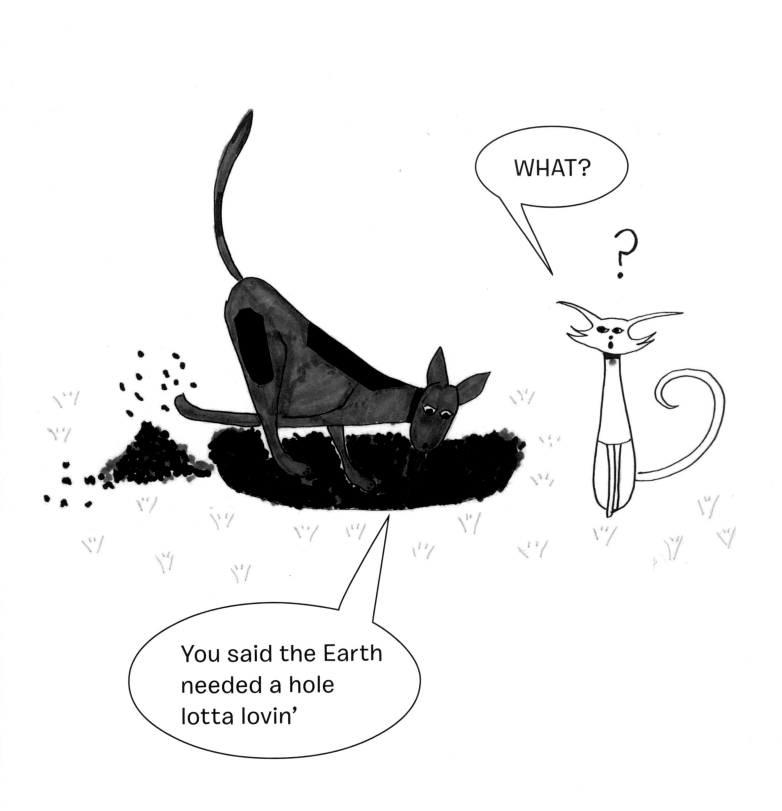

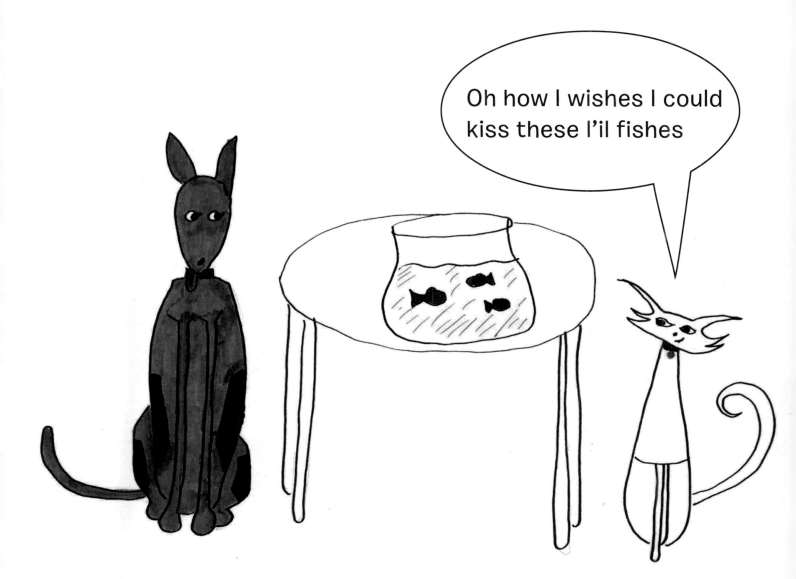

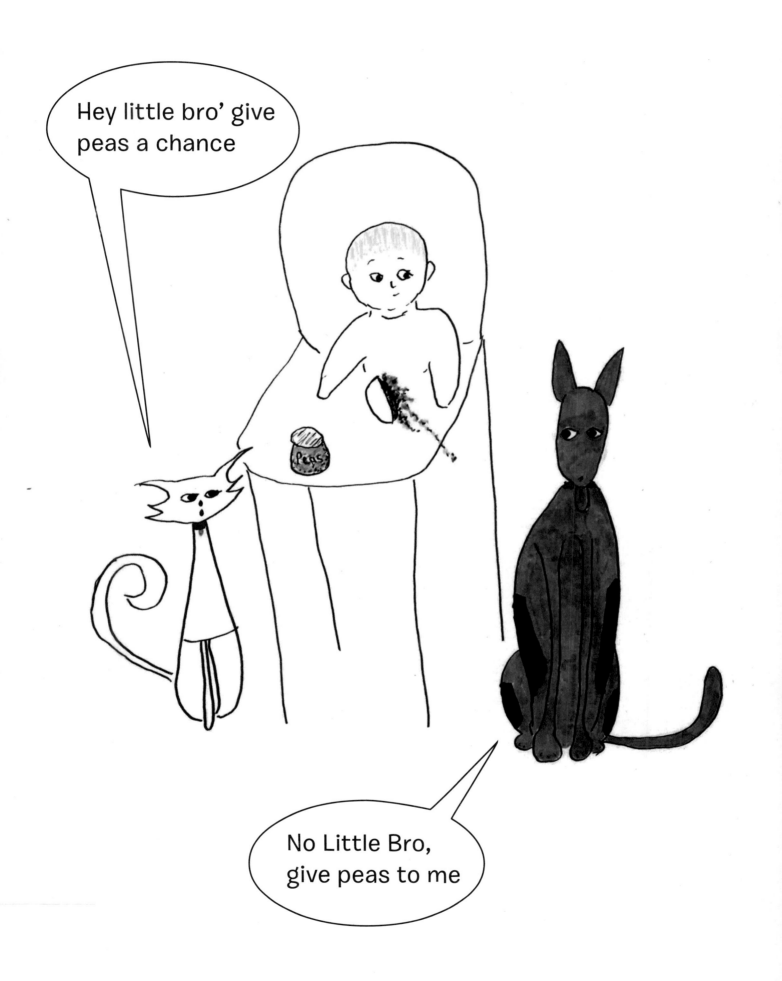

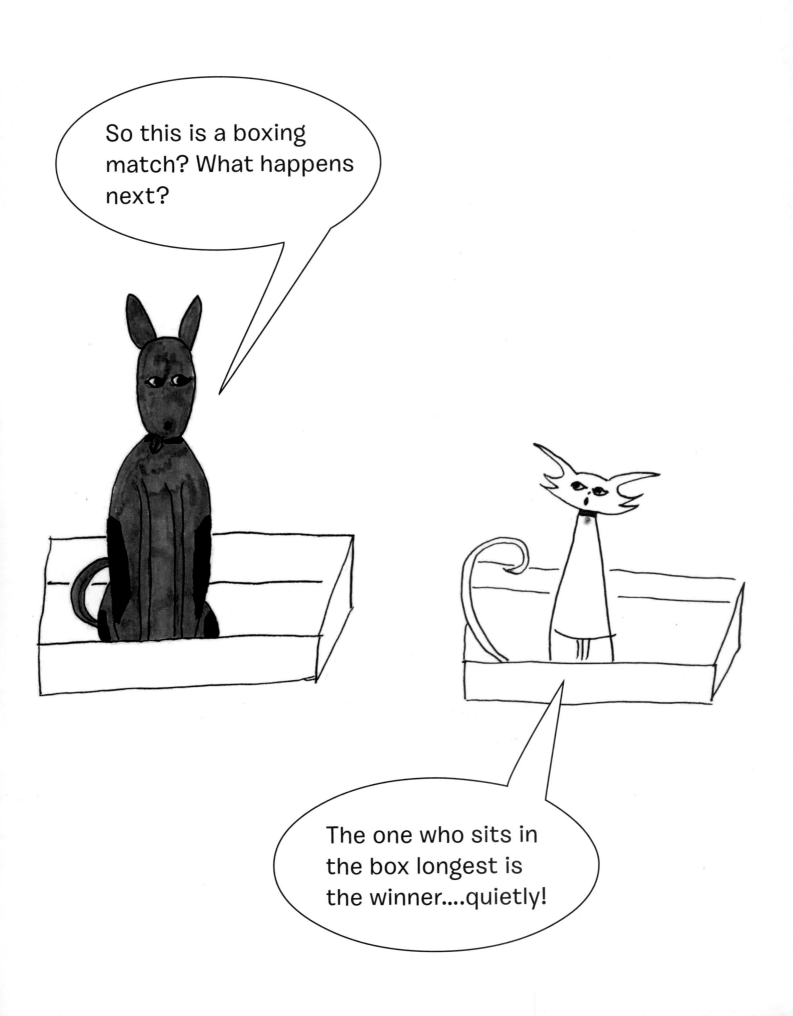

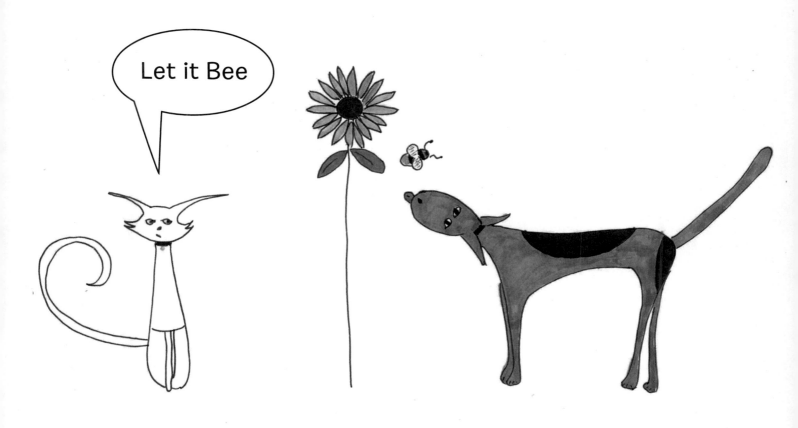

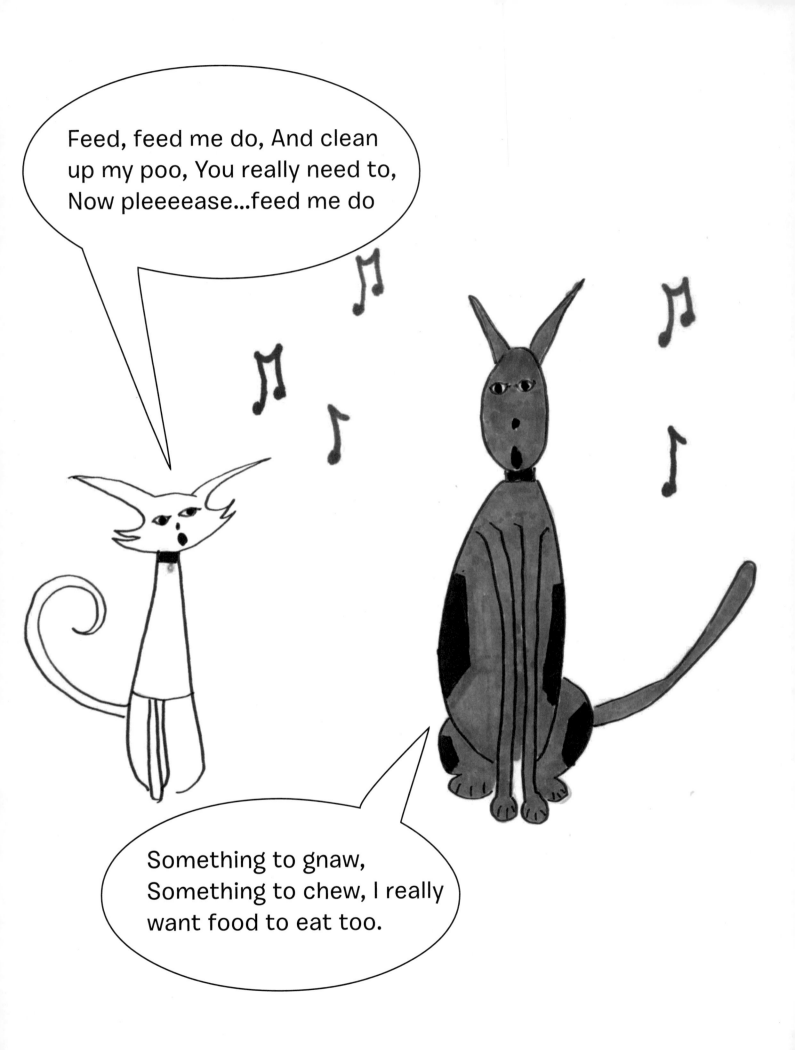

World Peace Nap-
In in progress

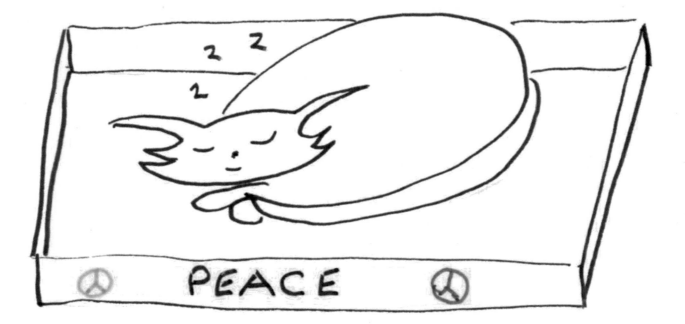

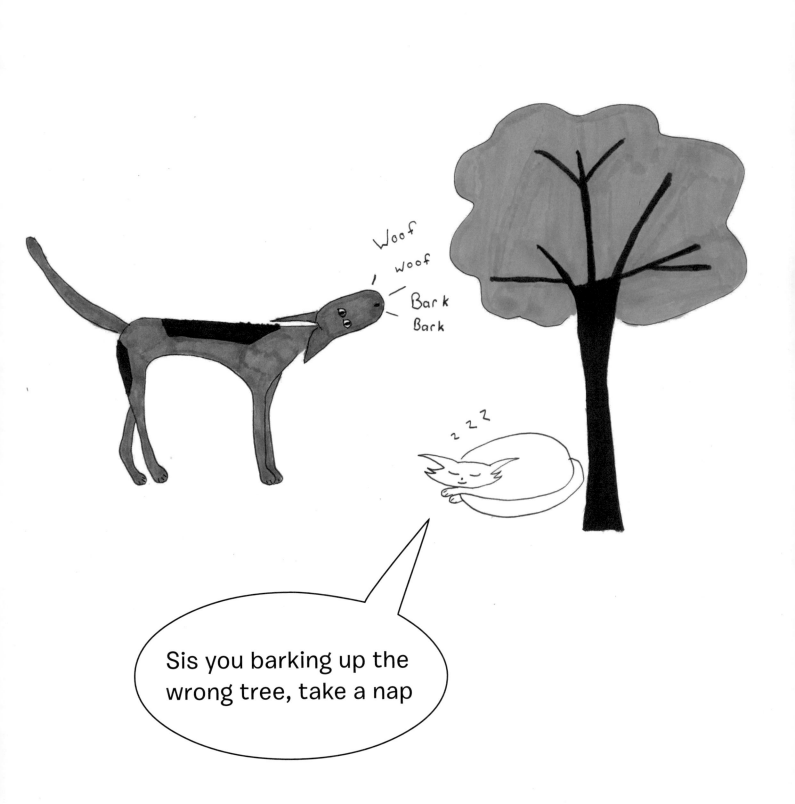

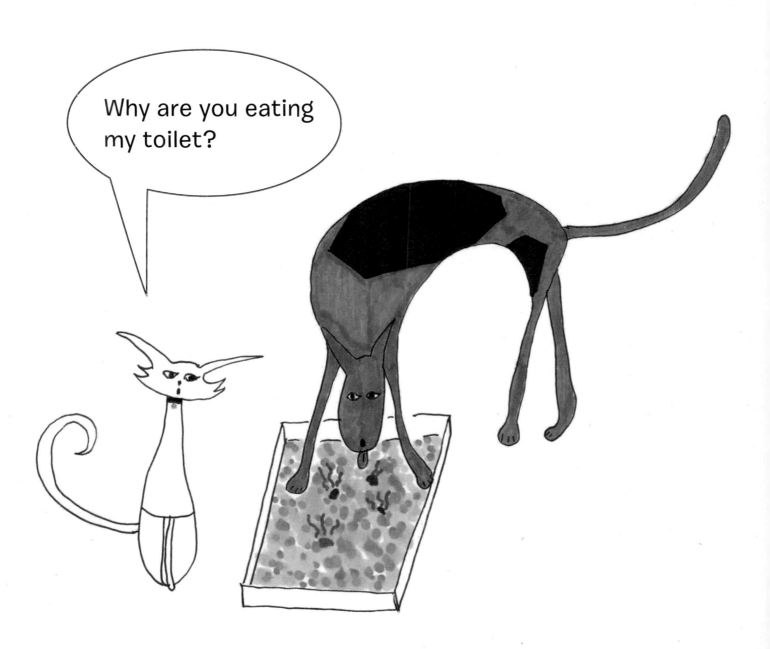

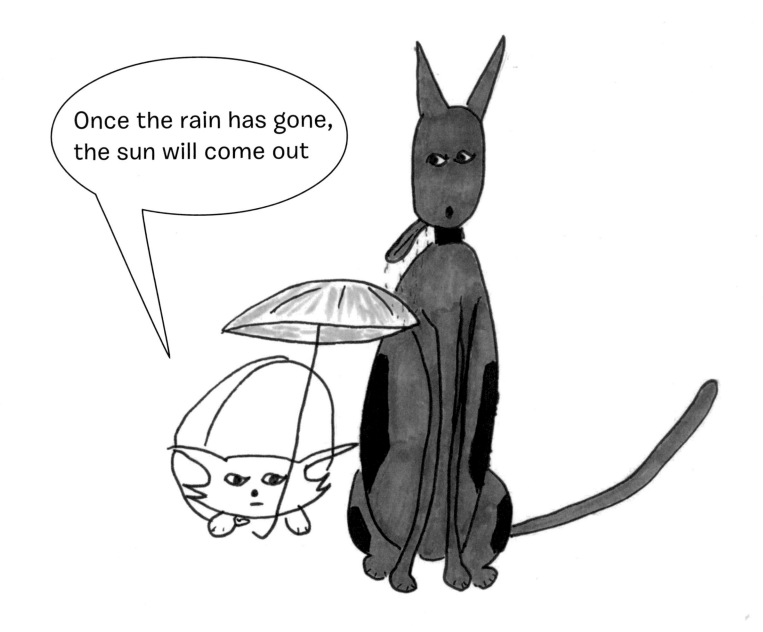

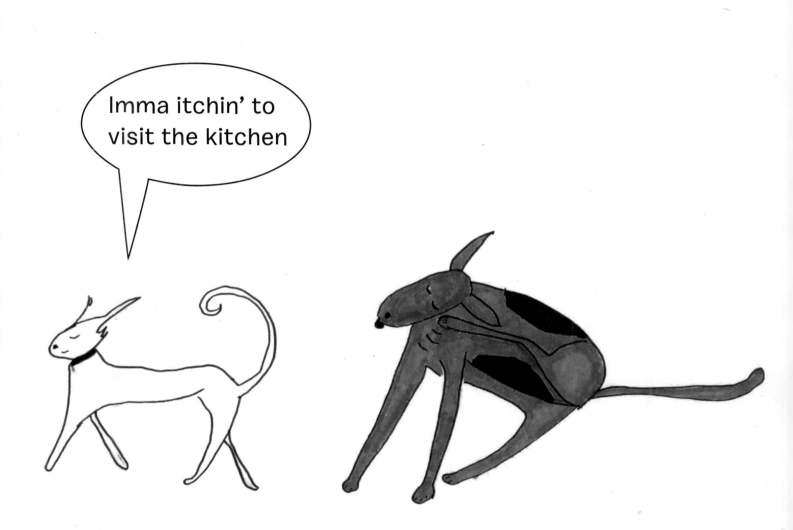

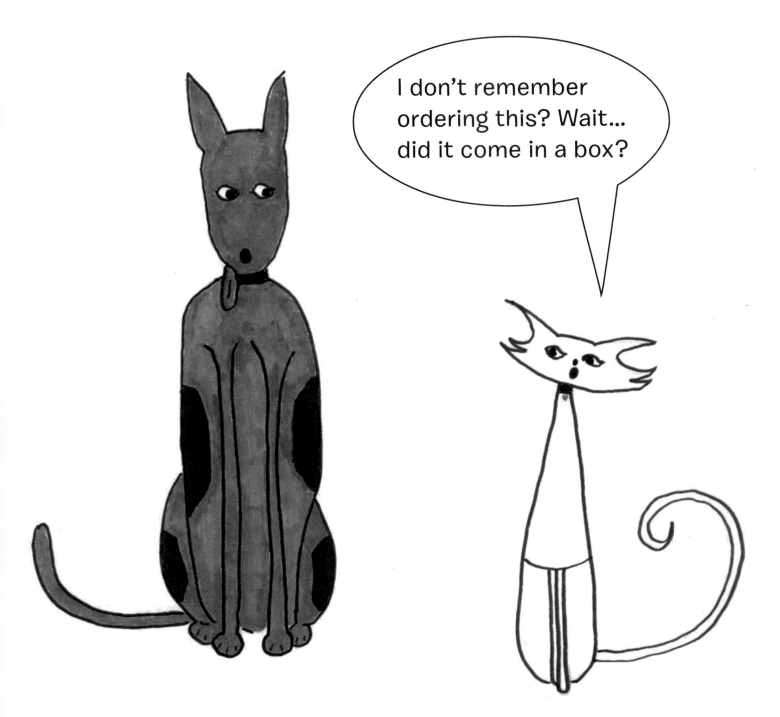

Dedication

This book is dedicated to Sage, our beautiful German Shepherd.

Acknowledgements

I would like to offer a special heart thanks to my wonderful partner, Gord, for supporting me in the creation of this book. I also want to thank my readers, wherever you may reside, for supporting my artistic goals. Your warm thoughts and well wishes are gratefully received and appreciated. I wish each and every one of you the very best life has to offer.

Interior Image Credit: Julie Rose

Copies may be ordered via
www.sassy-cat.com

Balboa Press books may be ordered through booksellers or by contacting:

Balboa Press
A Division of Hay House
1663 Liberty Drive
Bloomington, IN 47403
www.balboapress.com
1 (877) 407-4847

ISBN: 978-1-9822-2594-0 (sc)
ISBN: 978-1-9822-2595-7 (e)

Library of Congress Control Number: 2019904335

Print information available on the last page.

Balboa Press rev. date: 04/11/2019

BALBOA.
PRESS
A DIVISION OF HAY HOUSE

(A Sassy Cat Cartoon)
Crazy Paws

Howl with
Laughter

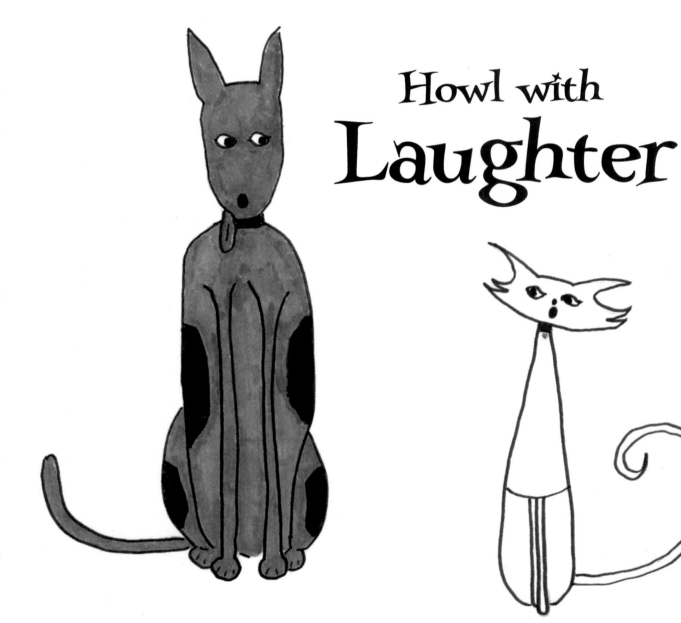

JULIE ROSE

Printed in the United States
By Bookmasters